PLAN B

Paul Muldoon

PLAN B

Photographs by Norman McBeath

ENITHARMON PRESS

First published in 2009
by Enitharmon Press
26B Caversham Road
London NW5 2DU

www.enitharmon.co.uk

Distributed in the UK by
Central Books
99 Wallis Road
London E9 5LN

Distributed in the USA and Canada
by Dufour Editions Inc.
PO Box 7, Chester Springs
PA 19425, USA

ISBN: 978-1-904634-82-9 (hardback)
ISBN: 978-1-904634-83-6 (signed limited edition)

Enitharmon Press gratefully acknowledges the financial support of
Arts Council England, London.

British Library Cataloguing-in-Publication Data.
A catalogue record for this book is available
from the British Library.

Designed in Lexicon by Libanus Press Ltd
and printed in England by
CPI Antony Rowe

CONTENTS

INTRODUCTION

I've been a fan of the photographs of Norman McBeath since I met him first in Oxford. He has that rare ability to allow nothing, least of all himself, to come between the subject of a photograph and the perceiver. That holds true of a sheep or a statue of Apollo in transit; the medium does not impose a sense of mediation. There is, rather, an invitation to *meditate*. The very idea of a 'subject' soon begins to seem crudely inappropriate.

It was to the photograph of Apollo in transit that I felt I might be most likely to respond directly as, over the last couple of years, Norman and I considered ways in which we might collaborate. The photograph has a kinetic, kinky aspect, and I imagined writing a kinetic, kinky poem in return.

I was, however, very conscious of the difficulties of poems and photographs responding to each other in kind, of one given 'in return' for the other. The hazards of a one-to-one relationship between word and image have never been more tellingly revealed than in Monty Python's spoof news broadcast in which a voice-over refers to 'the Lord Privy Seal' while we're given, in quick succession, shots of Dalí's *Christ of St John of the Cross*, a toilet-bowl and a shiny seal balancing a shiny ball on its nose.

It was with all this in mind that I sat one evening with the photographs and copies of the poems contained in *Plan B* and, like the kind of party host we've all been encouraged to believe ourselves to be, allowed them to get into conversation with each other. Before I knew it, they were making all sorts of connections of their own, none right-in-your-face except for the connection between the photo of Apollo in transit and the 'Apollo wrapped in polythene' referred to in 'Wayside Shrines', yet all somehow revelatory, all accompanied by little grunts, the grins and grimaces of recognition.

It would not be too much of a stretch, then, to say that this combination of poems and photographs was curated neither by Norman McBeath nor me but by the poems and photographs themselves.

<div align="right">PM</div>

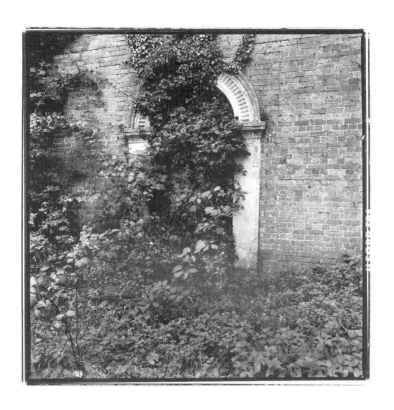

PLAN B

I

On my own head be it if, after the years of elocution and pianoforte,
the idea that I may have veered

away from the straight
and narrow of Brooklyn or Baltimore for a Baltic State

is one at which, all things being equal, I would demur.
A bit like Edward VII cocking his ear

at the mention of Cork. Yet it seems I've managed nothing more
than to have fetched up here.

II

To have fetched up here in Vilna – the linen plaids,
the amber, the orange-cap boletus

like a confession extorted from a birch,
the foot-wide pedestal upon which a prisoner would perch

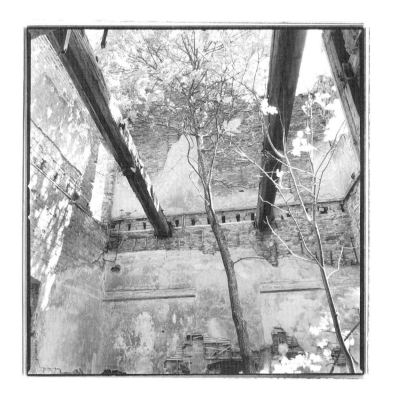

on one leg in the former KGB headquarters
like a white stork

before tipping into a pool of icy water,
to be reinstated more than once by a guard with a pitchfork.

 III

It was with a pitchfork they prodded Topsy, the elephant
that killed her keeper on Coney Island

when he tried to feed her a lit cigarette,
prodded her through Luna Park in her rain-heavy skirt

to where she would surely have been hanged by the neck
had the ASPCA not got themselves into such a lather

and Thomas Edison arrived in the nick
of time to greet the crowd he'd so long hoped to gather.

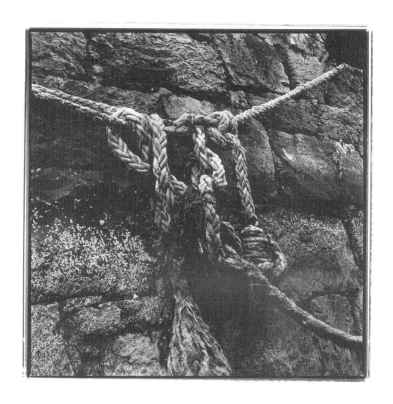

IV

I myself have been trying to gather the dope
from a KGB surveillance tape

on the Chazon Ish, 'the wisest Jew alive,' a master of the catch-all
clause who was known to cudgel

his brains in a room high in a Vilna courtyard
on the etymology of 'dork'

while proposing that the KGB garotte
might well be a refinement of the Scythian torc.

V

The Scythian torc had already been lent a new lease
of life as the copper wire with which Edison would splice

Topsy to more than 6,000 volts of alternating current,
though not before he'd prepared the ground

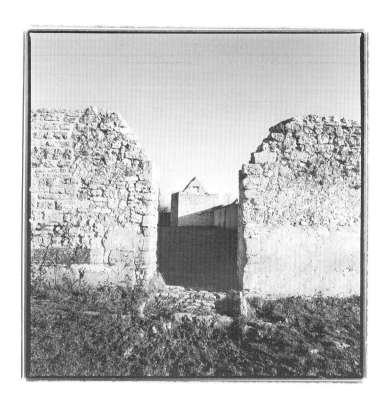

with a boatload of carrots laced with cyanide.
This was 1903. The year in which Edward VII paid

out a copper line from his mustachioed snout
to the electric chair in which Edison was now belayed.

 VI

Now a belayed, bloody prisoner they've put on the spot
and again and again zapped

is the circus rider on a dappled
croup from which he's more than once toppled

into the icy water, spilling his guts
about how his grandfather had somehow fetched up in Cork

straight from the Vilna ghetto,
having misheard, it seems, 'Cork' for 'New York.'

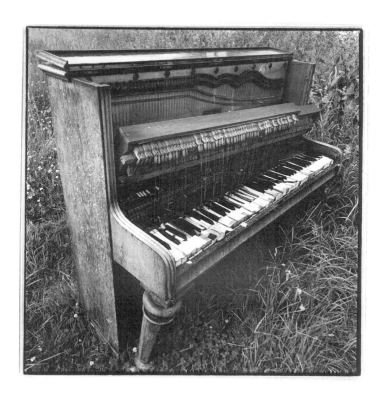

VII

For New York was indeed the city in which the floor teetered
at a ball thrown in 1860 in honor of Edward

(then Prince of Wales), the city in which even I may have put
myself above all those trampled underfoot,

given my perfect deportment all those years I'd skim
over the dying and the dead

looking up to me as if I might at any moment succumb
to the book balanced on my head.

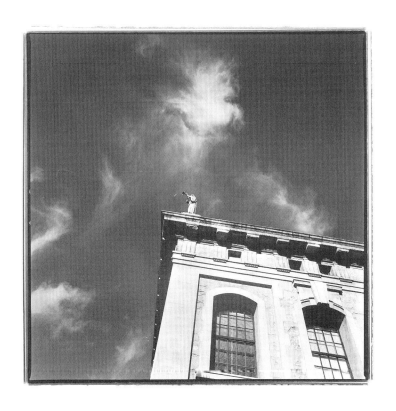

EXTRAORDINARY RENDITION

I

I gave you back my claim on the mining town
and the rich vein we once worked,
the tumble-down
from a sluice-box that irked

you so much, the narrow-gauge
that opened up to one and all
when it ran out at the landing-stage
beyond the Falls.

I gave you back oak ties,
bully-flitches, the hand-hewn cross-beams
from which hung hard tack

in a burlap bag that, I'd surmise,
had burst its seams
the last night we lay by the old spur track.

II

You gave me back your frown
and the most recent responsibility you'd shirked
along with something of your renown
for having jumped from a cage just before it jerked

to a standstill, your wild rampage
shot through with silver falderals,
the speed of that falling cage
and the staidness of our canyon walls.

You gave me back lake-skies,
pulley-glitches, gully-pitches, the reflected gleams
of two tin plates and mugs in the shack,

the echoes of love-sighs
and love-screams
our canyon walls had already given back.

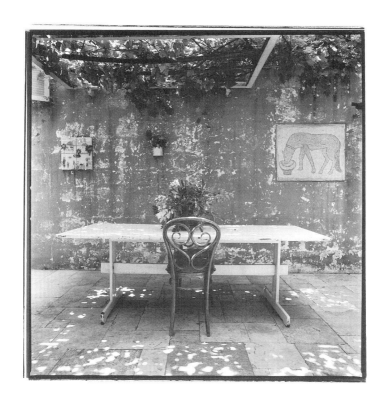

A MAYFLY

A mayfly taking off from a spike of mullein
would blunder into Deichtine's mouth to become Cuchulainn,
Cuchulainn who had it within him to steer clear
of a battlefield on the shaft of his own spear,
his own spear from which he managed to augur
the fate of that part-time cataloguer,
that cataloguer who might yet transcend the crush
as its own tumult transcends the thrush,
the thrush that's known to have tipped off avalanches
from the larch's lowest branches,
the lowest branches of the larch
that model themselves after a triumphal arch,
a triumphal arch made of the femora
of a woman who's even now filed under *Ephemera*.

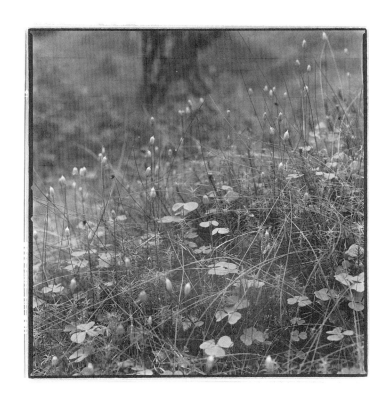

FRANÇOIS BOUCHER: *ARION ON THE DOLPHIN*

I

A rock-god waiting in the wings
to set himself before the king,
this eye-linered and lip-glossed Arion fouters
with his lyre's five strings

across the span
of twenty-five centuries. His big hair's bigger than ever from the fan
of a wind-machine. The sky's pinks and pewters
resound in the brain-pan

of a bloodied Triton still grasping his horn
through a brine-flurry
while the doo-wop chorus

of Nereids or such sea-born
nymphs seem content to hold their hurry
till those twenty-five centuries have taken their course.

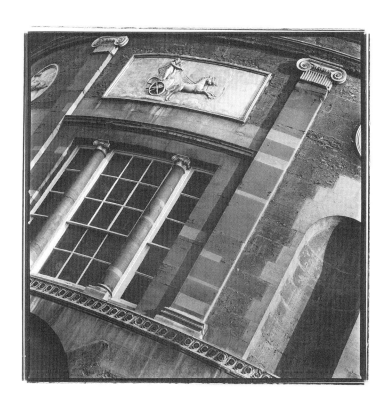

II

A course that was laid long before the keel of oak
was laid to soak
in Piraeus, got to be, long before murrey
would infiltrate his cloak,

the mulberry over which Arion will mull
long after a Triton's skull
explodes. Not to worry, he'll muse, not to worry
if the top-heavy hull

is shortly a hulk through which they'll pick
as they'll pick through the rubble
of the Depository elevator-shaft. What's not to love about the Teflon,

its non-stick
complete with the dead giveaway of a three-day stubble
on the cheek of a dolphin?

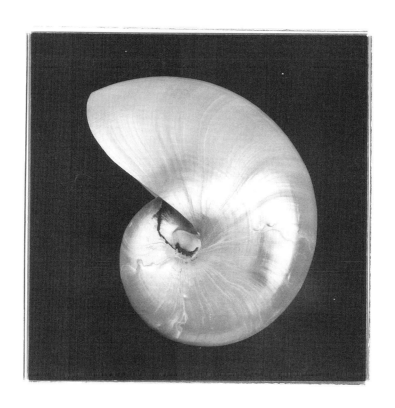

III

Less dolphin this than dog, dog-paddling through drifts of brine,
bearing a keg of brandy-wine
for lost sea-mountaineers. Less dolphin than double
of the figurehead of the ship in sharp decline

behind him, this sudden displacement of teak
suggesting the outlook's bleak
for both dolphin and *Dauphin*, spelling trouble
for another figurehead who'll soon barely squeak

through the ranks of sans-culottes
and the tumbrils' rough and tumble
to die in a shitty kennel

at the age of ten, a boy king going down at a rate of knots
through the scumble
of pewter and pink on a distant grassy knoll.

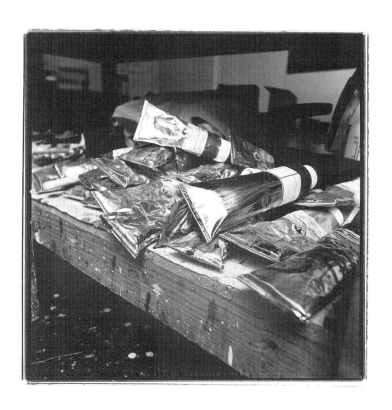

IV

On a grassy knoll two Tritons dressed as tramps
are doing the Versailles vamp
while, high above the rumble,
another is aiming to put his stamp

on something. The Nereid as a flitch
of halibut, caught without a stitch
on this holiest of days. Not to worry if we fumble
as we bait and switch

in a storm-sewer that might turn a mill
never mind a rumor-mill. In a bit of a pickle,
that Nereid, who shows such pluck

before the likelihood of everything going downhill
like the trickle
of blood from a, got to be, butcher-block.

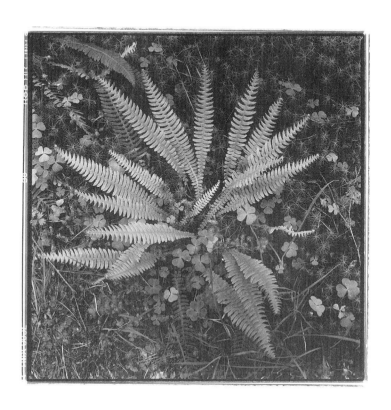

V

Not to worry if the butcher massaging the rump
of a Nereid is *le boucher*, plumping and plumping the very clump
at which he'll prickle.
The Triton in a slump

across the raft has taken a hit
to the throat. The Nereid who's lost her kit
and might once have been up for a little slap and tickle
may now never know just how interknit

are herself and the lymph
in which her hair streams like a, got to be, streamer.
What's not to love about this vestige

of the tail of a water-nymph
who might learn within the week it's not the blue-green of a scaly femur
but gangrene kicking into its second stage?

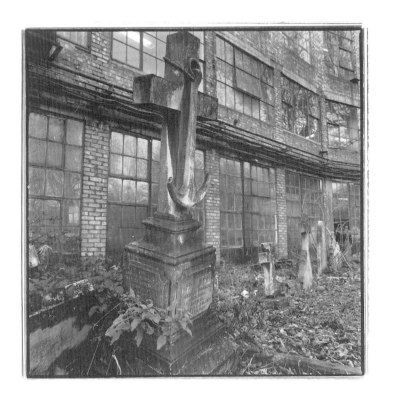

VI

The second stage where the rock-god needs to simultaneously touch
and turn away from those who need to clutch
at him while kissing him off. What's not to love about a steamer
going down and, insomuch

as we may deduce if night will bring release
from his tribulations and his safe return to Greece,
about a Triton torn between nuzzling the calf of his redeemer
and gnawing it, this raft now being of a piece

with the raft of the *Medusa* and the raft
of the sunk PT-109, though neither he nor his fellow trumpet-tooters
may ever begin to drag out

the connection between the elevator-shaft
and the storm-sewer where the third of the shooters
waits in the wings for the motorcade?

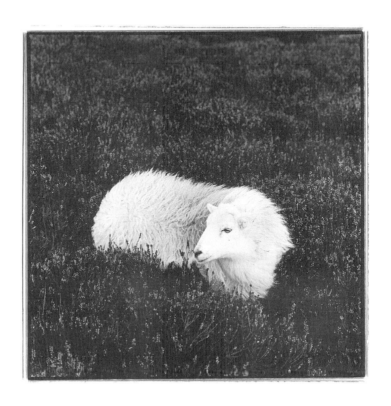

from WAYSIDE SHRINES

I

Having myself been run out of town
I might easily have gone down on my knees
by each white cross or posy in its tin
and resigned myself to the fact
a cord of dead wood may be stacked
between two living trees.
Even an acorn tastes bitter
to the runt of the litter
when it begins to feel the squeeze
yet those pigs had seemed content
in their profound disgruntlement.

II

Had I had more than a glimpse of a lake
through a break in a plateau,
had I not suddenly been forced to brake
for Apollo wrapped in polythene,
I might have been emboldened

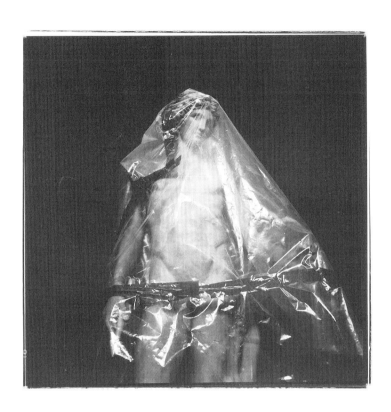

and gone with the flow.
Even a road resists being led to water
like a lamb to the slaughter
at ISAAC'S TRUCK & TOW
yet smoke had risen with next-to-no-fuss,
calm above the calamitous.

III

Now as gas prices soared
another billboard had held out *INJURED?*
before it all but implored
1-888-WE-CAN-HELP.
I caught the yelp
from a clothesline of a plaid work-shirt.
Even a bald-faced bullock may falter
as it mounts an altar
that's little more than a pile of dirt
yet a storm-window took a stance
against what it must discountenance.

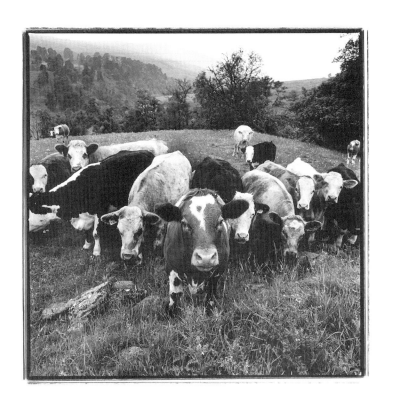

THE SOD FARM

Her car must have caught fire
when she missed a turn
or blew a tire,
the girl with third-degree burns

who slammed into a tree
by the mist-shrouded sod farm.
40%. Third-degree.
Her gauze-wrapped arms

now taking in unending variations
and surprises: temples, grottoes,
waterfalls, ruins, leafy glades

with sculpture, and such features
as would set off the imagination
on journeys in time as well as space.

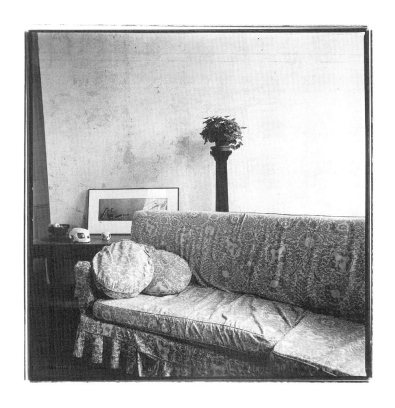

THE WATER COOLER

They're poisoning the atmosphere
now you and I've split,
coming out of the dark
to make those acid remarks
to all and sundry
because they're trying to get something clear.
The mistletoe puts up its mitts

now you and I've split.
The black oaks jostle
bark on careworn bark
to make those acid remarks
at the Christmas party
and the mistletoe puts up its mitts
to vie for the sweet-throated throstle

where the black oaks jostle
over a back fence
in the industrial park.

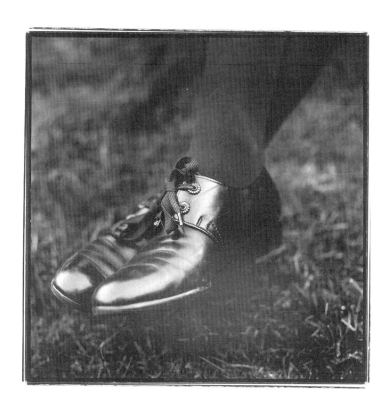

As they make those acid remarks
in the third-floor Ladies
and vie for the sweet-throated throstle,
the black oaks seem no less tense

over a back fence
than the chestnuts dishing the dirt.
Even the sweet-throated lark
will make those acid remarks
to all and sundry,
seeming no less tense
than so many introverts,

than the chestnuts dishing the dirt
down by the water cooler
about our being found stark
naked in the copy-room. Such acid remarks
at the Christmas party.
Like so many introverts,
like all the other carpoolers

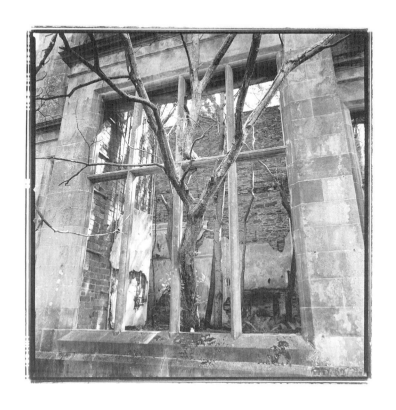

down by the water cooler,

the chestnuts cough up their lungs

and hint that it's only the payroll clerks

would make such acid remarks

in the third-floor Ladies.

Like all those other carpoolers,

the maples wag their tongues

and cough up their lungs

because they're trying to get something clear.

Something about our rekindling the spark

being the burden of their acid remarks

to all and sundry.

The maples wag their tongues.

They're poisoning the atmosphere.

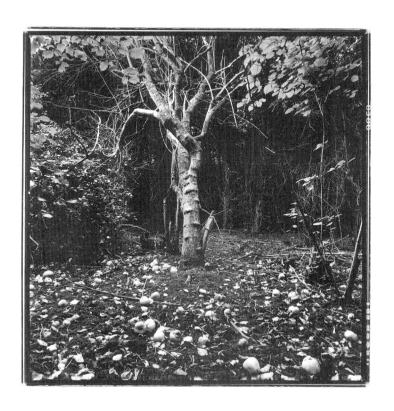

THE ROWBOAT

I

Every year he'd sunk
the old, clinker-built rowboat
so it might again float.
Every year he'd got drunk

as if he might once and for all write off
every year he'd sunk,
kerplunk, kerplunk,
one after another into a trough

no water would staunch.
Like a waterlogged tree trunk,
every year he'd sunk
just as he was about to launch

into a diatribe on the chunk
of change this bitch
was costing him, the debt into which
every year he'd sunk.

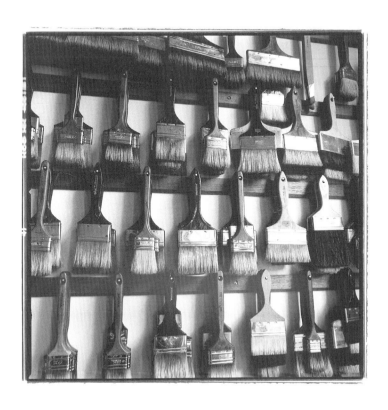

II

The old, clinker-built rowboat
with its shriveled strakes
would be immersed in the lake,
the lake that itself rewrote

many a stage play for the big screen.
The old, clinker-built rowboat
in which he'd stashed the ice-tote
from L.L. Bean

for Crested Ten on the rocks
(one part Crested Ten, two parts creosote),
the old, clinker-built rowboat
he'd threatened to leave on the dock

and give a coat
of varnish that would somehow clinch the deal,
that would once and for all seal
the old, clinker-built rowboat.

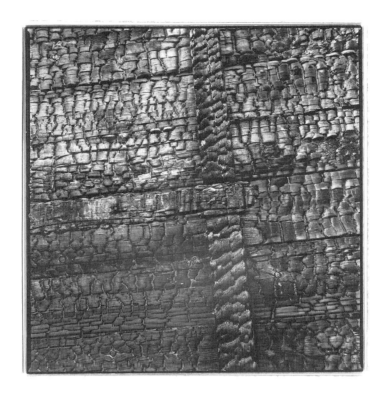

III

So it might again float
the possibility one must expand
with Coutts and Co. (without the ampersand),
misquoting them as one might misquote

the price of Paramount stock
so it might again float.
More than once he'd written a promissory note
and put himself in hock

more than once to assuage
the fears for a property expressed by the Coutthroats
so it might again float
from the big screen to the stage

and gain by losing something of its bloat,
taking as he did the chance
it might be imbued with some new significance
so it might again float.

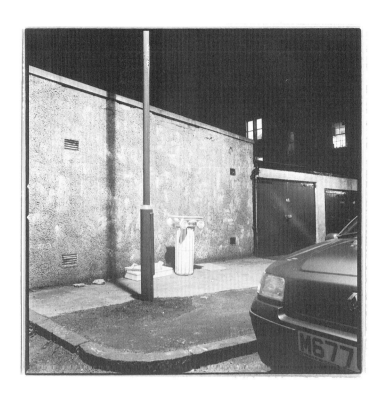

IV

Every year he'd got drunk
and railed at this one and that,
the baseball-birdbrain, the basketball-gnat,
the gin-soaked punk

he threatened with a punching out of lights
every year he'd got drunk,
the Coutts & Co. quidnunc
whose argument was no more watertight

than any by which he might inure
himself against the basketball-gnat's slam dunk.
Every year he'd got drunk
but resisted taking a cure

just as every year he'd shrunk
from the thought, kerpow,
he'd most likely go under given how
every year he'd got drunk.

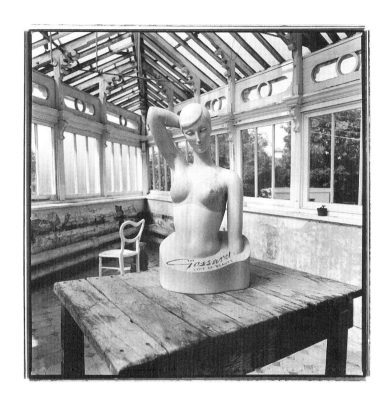

A HUMMINGBIRD

At Nora's first post-divorce Labor Day bash
there's a fluster and a fuss and a fidget
in the fuchsia-bells. 'Two fingers of sour mash,
a maraschino cherry.' 'So the digit's
still a unit of measurement?' 'While midgets
continue to demand a slice of the cake.'
'A vibrator, you know, *that* kind of widget.'
Now a ruby-throated hummingbird remakes
itself as it rolls on through mid-forest brake.
'I'm guessing she's had a neck-lift *and* lipo.'
'You know I still can't help but think of the *Wake*
as the apogee, you know, of the typo.'
Like an engine rolling on after a crash,
long after whatever it was made a splash.

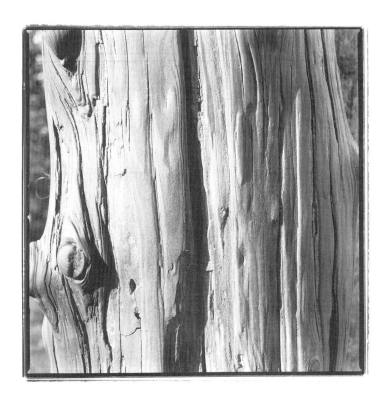

A HARE AT ALDERGROVE

A hare standing up at last on his own two feet

in the blasted grass by the runway may trace his lineage to the great

assembly of hares that, in the face of what might well have looked

 like defeat,

would, in 1963 or so, migrate

here from the abandoned airfield at Nutt's Corner, not long after

 Marilyn Monroe

overflowed from her body-stocking

in *Something's Got to Give*. These hares have themselves so long been

 given to row

against the flood that when a King

of the Hares has tried to ban bare-knuckle fighting, so wont

are they to grumble and gripe

about what will be acceptable and what won't

they've barely noticed that the time is ripe

for them to shake off the din

of a pack of hounds that has caught their scent

and take in that enormity just as I've taken in

how my own DNA is 87% European and East Asian 13%.

So accustomed had they now grown

to a low level human hum that, despite the almost weekly atrocity

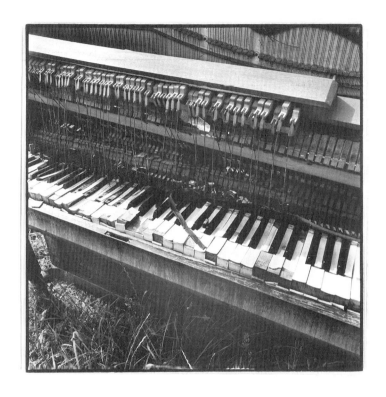

in which they'd lost one of their own

to a wheeled blade, they followed the herd towards this eternal city

as if they'd had a collective change of heart.

My own heart swells now as I watch him nibble on a shoot

of blaeberry or heather while smoothing out a chart

by which he might somehow divine if our Newark-bound 757 will

 one day overshoot

the runway about which there so often swirled

rumors of Messerschmitts.

Clapper-lugged, cleft-lipped, he looks for all the world

as if he might never again put up his mitts

despite the fact that he shares a Y chromosome

with Niall of the Nine Hostages,

never again allow his Om

to widen and deepen by such easy stages,

never relaunch his campaign as melanoma has relaunched its campaign

in a friend I once dated,

her pain rising above the collective pain

with which we've been inundated

as this one or that has launched an attack

to the slogan of 'Brits Out' or 'Not an Inch'

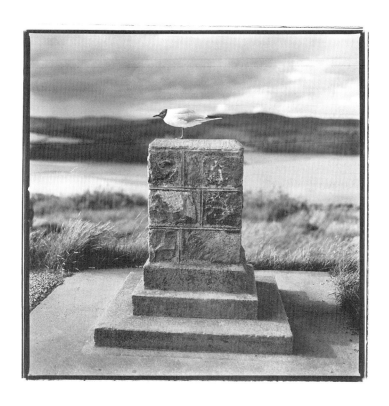

or a dull ack-ack

starting up in the vicinity of Ballynahinch,

looking for all the world as if he might never again get into a fluster

over his own entrails,

never again meet luster with luster

in the eye of my dying friend, never establish what truly ails

another woman with a flesh wound

found limping where a hare has only just been shot, never again
 bewitch

the milk in the churn, never swoon as we swooned

when Marilyn's white halter-top dress blew up in *The Seven Year Itch*,

in a flap now only as to whether

we should continue to tough it out till

something better comes along or settle for this salad of blaeberry
 and heather

and a hint of common tormentil.

PHOTOGRAPHS